Face, head, and neck

Michel **Lauricella**

T0061822

Morpho: Face, head, and neck
Michel Lauricella

Editor: Jocelyn Howell
Project manager: Lisa Brazieal
Marketing coordinator: Katie Walker
Graphic design and layout: monsieurgerard.com
Layout production: Anthony Paular Design

ISBN: 979-8-88814-164-9
1st Edition (1st printing, April 2024)

Original French title: Morpho Tête et cou
© 2023, Éditions Eyrolles, Paris, France
Translation Copyright © 2024 Rocky Nook, Inc.
All illustrations are by the author

Rocky Nook, Inc.
1010 B Street, Suite 350
San Rafael, CA 94901
USA
www.rockynook.com

Distributed in the UK and Europe by Publishers Group UK
Distributed in the U.S. and all other territories by Publishers Group West

Library of Congress Control Number: 2023945243

Publisher's note: This book features an "exposed" binding style. This is
intentional, as it is designed to help the book lay flat as you draw.

CONTENTS

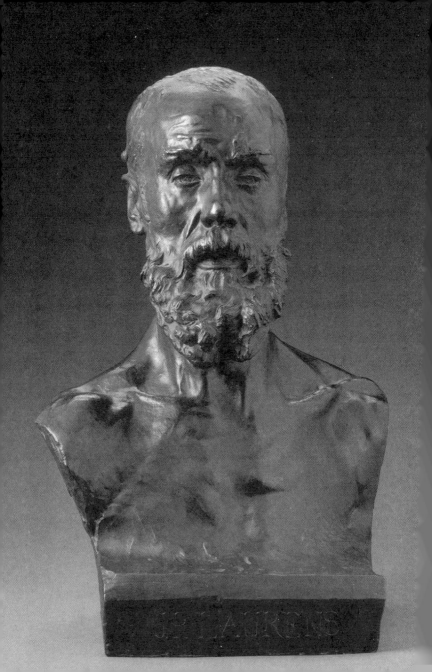

FOREWORD

The art of portraiture, whether sculpted, painted, drawn, photographed, or filmed, is a genre in itself. There are very fine examples of portraiture dating back to antiquity, and many contemporary artists also focus their research on this theme. While these representations have multiple functions—the faces given to Egyptian mummies, imperial propaganda portraits, portraits of famous people, self-portraits, passport photos, family portraits, movie close-ups, etc.—we find it completely natural that this fragment of the body should be entirely self-sufficient and able to evoke the whole person.

Every artist plays with representational codes. You might want to frame very tightly on the eyes and mouth, as film has made us accustomed to; widen the frame to include the whole face, as in a sculptural mask; pull back even more to cut the face below the chin; or go even lower and include the shoulders. Framed like this, the portrait can become a "bust," which then includes the head, neck, and chest—but not the arms. In order to best meet your needs, I will often choose this last version.

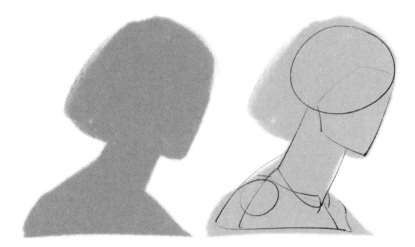

INTRODUCTION

The fact that thousands of human populations have been intermingling for millennia now makes the subject of this work inexhaustible and means that the art of the portrait will always remain vibrant. Our species, with its billions of individuals, offers an infinite number of variations on the same theme. We are particularly sensitive to the tiniest differences that make each and every one of us unique, especially because the creation of a portrait often triggers the search for resemblances. The "morpho" approach and the format of this small book, however, require us to take an extremely concise approach to the subject. All of the ideas about proportions, every attempt to define certain morphological characteristics of our species, will have to be reevaluated when you are face to face with your models. What I provide here is only a starting point, a framework that is inscribed into our Western culture. The canonical proportions that I use emerged from the Italian Renaissance and have been refined by more recent works, particularly those by Richer, Loomis, and others (see the Resources page). Similarly, what we call "sexual" characteristics are often indefinite, blended, and intermingled, and listing every characteristic would reduce their complexity to a caricature of itself. I will nonetheless attempt the exercise, but most often I will draw heads that remain androgynous in both children and adults, devoid of the most obvious cultural gender signals such as hairstyle, clothing, and body hair.

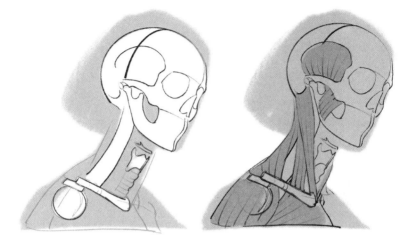

With that being said, the goal here is to find a way to simplify this reality, to allow us to memorize the basic shapes, so we can draw from our imagination and restore, by contrast, the uniqueness of each and every one of us.

The difficulties do not involve just the drawing of the head itself; the head also has to be connected with the torso. The classical version of the bust requires us to remember the structure of the front and back of the neck, the base of the shoulders, and the top of the torso. After that, we can play with the tilt and orientation of the head with relation to the axis of the shoulders.

In this book, I have brought together a number of drawings that were previously published in the earlier volumes of this collection. You will also find some previously unpublished diagrams, ideas about proportions as a function of age, some views from above, and some tips for drawing hair.

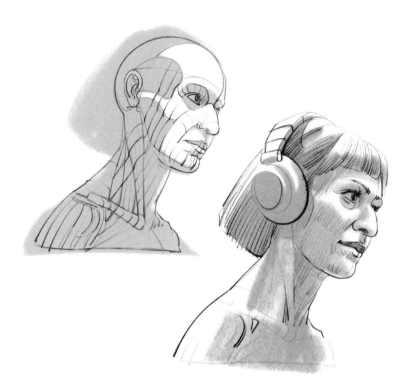

Rather than breaking up my remarks by area, from the head down to the shoulders, detailing each element of the face in turn, I propose here that we proceed layer by layer, repeating, over the course of the illustrative plates, a step-by-step operation that will show how, starting with basic shapes, we can add thickness by requiring ourselves to move through first the skeleton and then the musculature, then to erase, depending on the individual model, the anatomical details that are not important, many of which are hidden by fat, hair, or facial hair. I will "dress" some of the drawings, furnishing them with a variety of accessories that will, I hope, make the shape of the head easier to see, whether by contrast (as with the geometry of a pair of glasses) or ergonomically (as with a helmet).

ILLUSTRATIVE PLATES

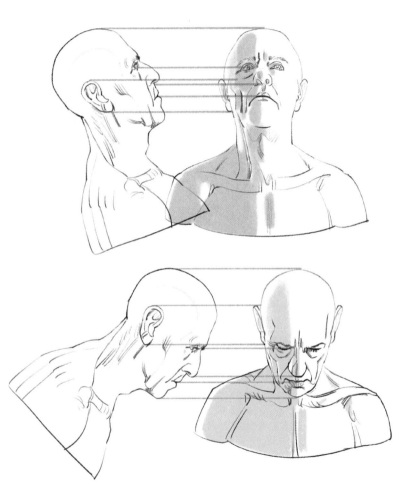

Proportions

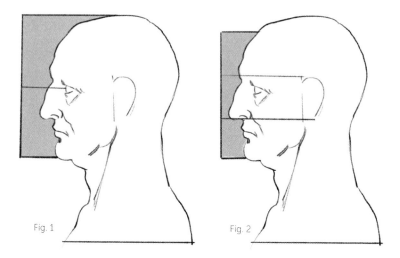

Fig. 1 Fig. 2

Fig. 1: I decided to start from the "classical" rule, which is easy to memorize because it positions the eyes, on an adult, halfway up. Leonardo da Vinci drew this very precisely and made large numbers of studies of heads that deviate from this proportion to show that the relevance of any such canonical rule is relative.

Fig. 2: Da Vinci distinguishes the face from the head and divides the face into three equal segments: the height of the nose in the middle, with an equal segment above it that designates the forehead ending at the hairline, and another equal segment below that ends at the point of the chin. The ear is placed at the level of the nose.

The drawings on the opposite page (copied from photographs) give more nuance to this point.

Fig. 3: This model is a perfect illustration of the rule that we have just looked at.

Fig. 4: I have often seen the ear placed as we see here, just a little lower down.

Figs. 5 and 6: The size of the jaw on both of these models means that the eyes are no longer halfway up the head, but are higher up.

Fig. 7: Here, by contrast, a smaller jaw brings the eyes down below the halfway reference point.

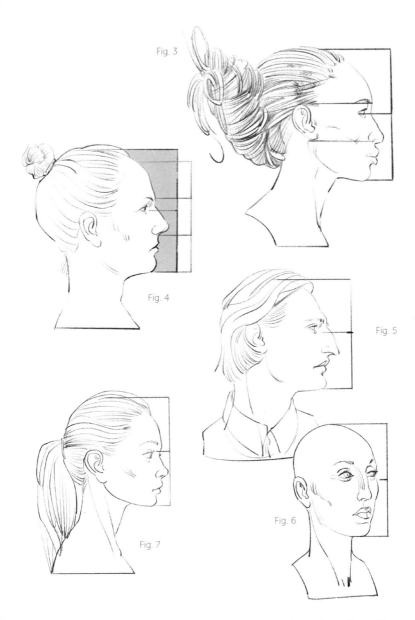

Fig. 3

Fig. 4

Fig. 5

Fig. 7

Fig. 6

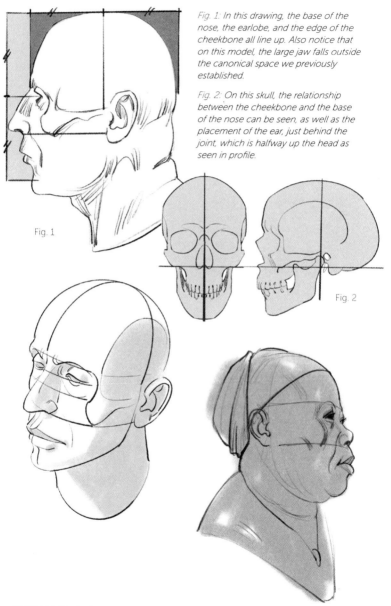

Fig. 1: In this drawing, the base of the nose, the earlobe, and the edge of the cheekbone all line up. Also notice that on this model, the large jaw falls outside the canonical space we previously established.

Fig. 2: On this skull, the relationship between the cheekbone and the base of the nose can be seen, as well as the placement of the ear, just behind the joint, which is halfway up the head as seen in profile.

Fig. 1

Fig. 2

The relationships between the nose, the cheekbones, and the ears must take into account the orientation and tilting movements of the head. (See also the illustration on page 10.)

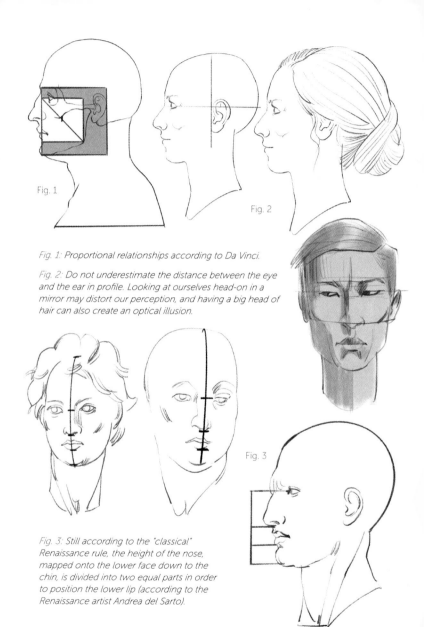

Fig. 1: Proportional relationships according to Da Vinci.

Fig. 2: Do not underestimate the distance between the eye and the ear in profile. Looking at ourselves head-on in a mirror may distort our perception, and having a big head of hair can also create an optical illusion.

Fig. 3: Still according to the "classical" Renaissance rule, the height of the nose, mapped onto the lower face down to the chin, is divided into two equal parts in order to position the lower lip (according to the Renaissance artist Andrea del Sarto).

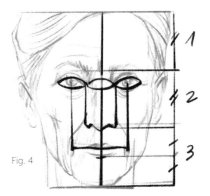

Fig. 4

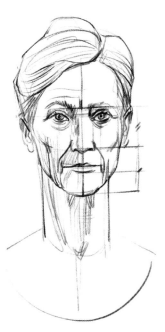

Fig. 4: The width of an eye can be fitted between the two eyes. The width of the nose can coincide with this proportion, whereas the corners of the lips are here lined up directly below the middle of the eyes. These are only mnemonic tips—the variations are endless, and asymmetry rules in the details!

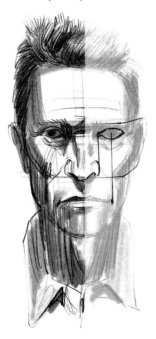

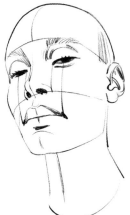

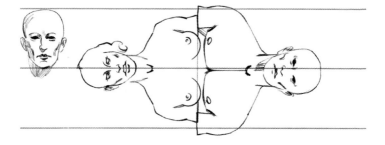

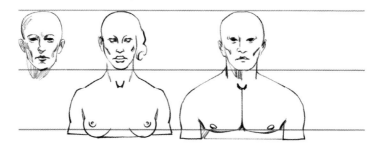

The head serves as a unit of measurement in many proportional canons (in this case, according to the anatomist Paul Richer). I will emphasize here the proportional relationships that can be useful to you if you are considering drawing a bust. Roughly speaking, the width of the shoulders corresponds to two head heights on an adult.

Children's heads are larger, relatively speaking. The relationship between the proportions of the head and the shoulders will help you to define the age of your models.

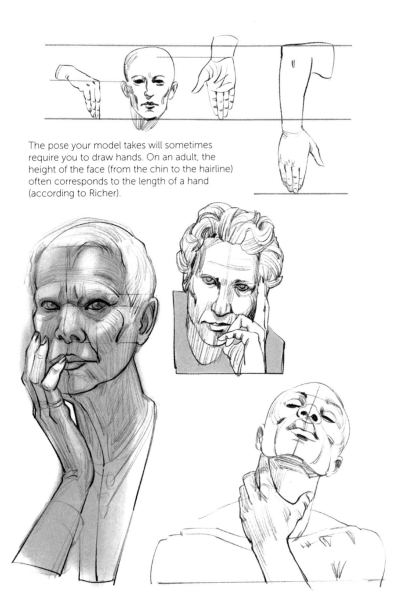

The pose your model takes will sometimes require you to draw hands. On an adult, the height of the face (from the chin to the hairline) often corresponds to the length of a hand (according to Richer).

Fig. 1: The cervical portion of the spine (shaded area) usually measures about 13 cm on an adult (according to Mathias Duval), but the proportions of the neck can look very different. In these four drawings, the neck is the same height; however, the narrower a neck is, the longer it will appear. Add to these illusionistic effects, which are the result of fleshy masses (fat and/or muscular), the different sizes of the jaw as well as the effects of posture, especially how the shoulders are carried.

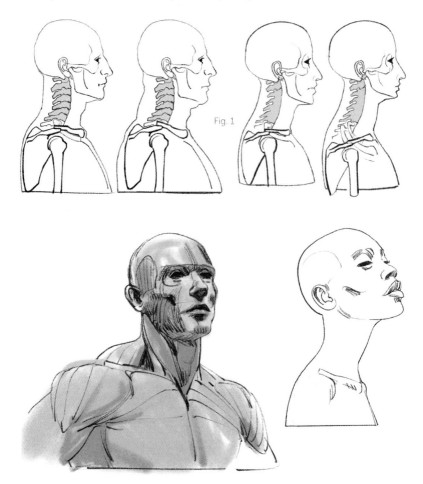

Fig. 1

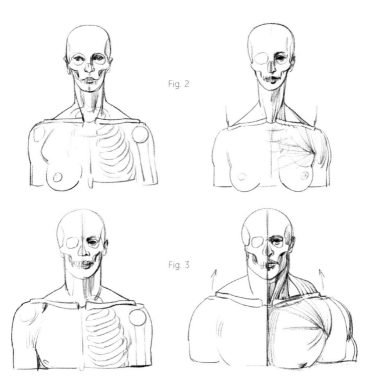

Fig. 2

Fig. 3

Figs. 2 and 3: The cervical vertebrae are all, again, the same height in all of these different drawings: I imagine the joint under the skull, behind the jawbones (Fig. 1). The neck appears longer if we combine a small jaw with a slender musculature and drooping shoulders; conversely, it appears shorter when combined with a strong jaw, a powerful musculature, and raised shoulders.

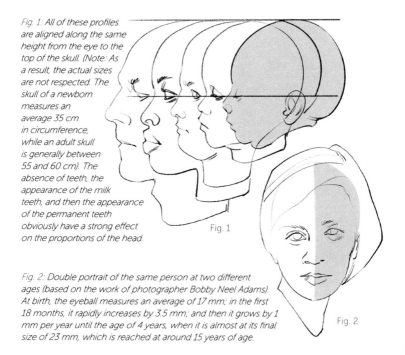

Fig. 1: All of these profiles are aligned along the same height from the eye to the top of the skull. (Note: As a result, the actual sizes are not respected. The skull of a newborn measures an average 35 cm in circumference, while an adult skull is generally between 55 and 60 cm). The absence of teeth, the appearance of the milk teeth, and then the appearance of the permanent teeth obviously have a strong effect on the proportions of the head.

Fig. 1

Fig. 2: Double portrait of the same person at two different ages (based on the work of photographer Bobby Neel Adams). At birth, the eyeball measures an average of 17 mm; in the first 18 months, it rapidly increases by 3.5 mm; and then it grows by 1 mm per year until the age of 4 years, when it is almost at its final size of 23 mm, which is reached at around 15 years of age.

Fig. 2

Fig. 3: On the same basic sketch, the eyes are raised and somewhat reduced in size. This same person now seems to be represented at several different ages. This drawing tip will be borne out in the studies on the following pages, based on photographs.

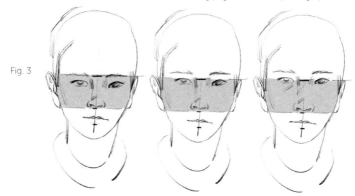

Fig. 3

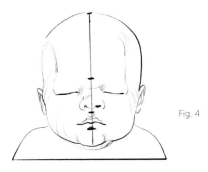

Fig. 4

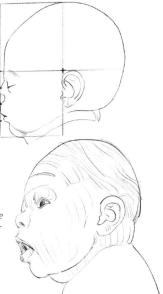

Fig. 4: Looking for mnemonic reference points that hold true for a large number of newborns, I find that the middle of the head height is about at the eyebrow arch. Then, following the subdivision of the head into four equal parts, as proposed by illustrator Andrew Loomis, I would place the lower eyelid in the first quarter and the lower lip in the last quarter.

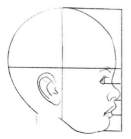

By making studies of many copies of photographs, I found that Loomis's measurements often hold true. Therefore, I will use his work as a basis for the end of this chapter.

Recall that Loomis subdivides the lower half of the head into four equal parts.

Fig. 1: Loomis method.

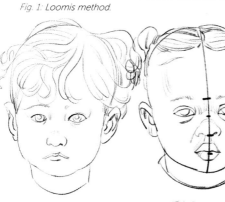

In these children, photographed in their first year, we find, once again, the eye in the first quarter, the nose in the second, the corner of the lips in the third, and the chin extending just beyond the fourth. Fat fills the cheeks and often lines the contours of the chin.

For the next three years, while the jaw grows (lowering the halfway point of the head height), the eye, the nose, and the mouth appear to move upward. Thus, the eye is now in the middle of the first quarter and the bottom of the lower lip is in the third. The nose continues to be small and rounded, and the nasal ridge is not yet developed.

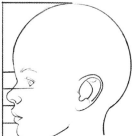

Fig. 2: Loomis method.

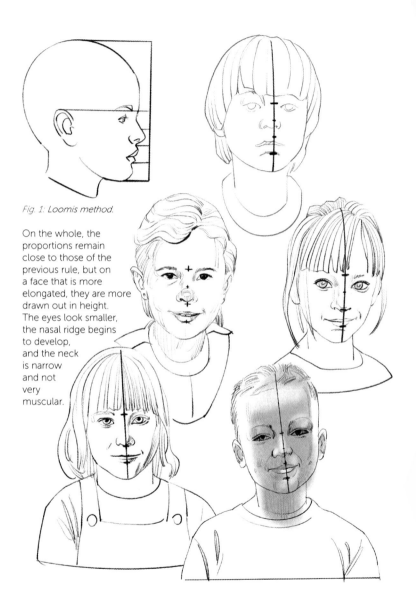

Fig. 1: Loomis method.

On the whole, the proportions remain close to those of the previous rule, but on a face that is more elongated, they are more drawn out in height. The eyes look smaller, the nasal ridge begins to develop, and the neck is narrow and not very muscular.

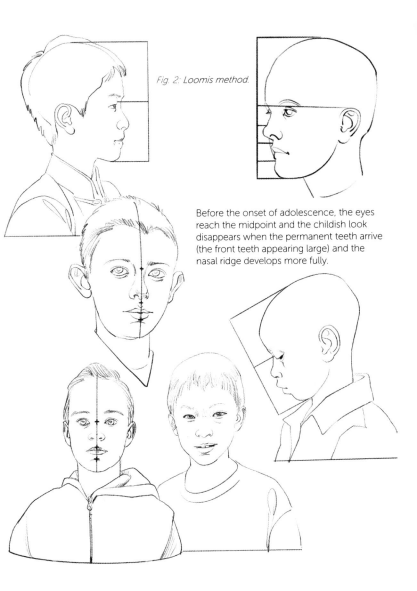

Fig. 2: Loomis method.

Before the onset of adolescence, the eyes reach the midpoint and the childish look disappears when the permanent teeth arrive (the front teeth appearing large) and the nasal ridge develops more fully.

In adolescence, the proportions are almost the same as in adults, but the shapes are often both rounder and firmer, without the expressive lines seen in adults.

Large differences in maturity can be observed depending on the individual, with changes toward adult forms beginning earlier in female adolescents.

The nose has come into its shape; the ear appears smaller; the angle of the jaw has not yet reached its full development.

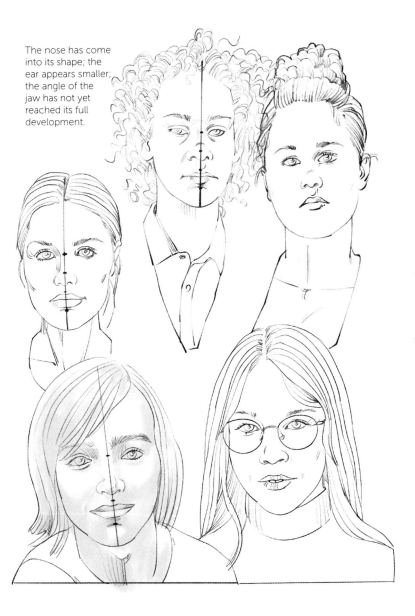

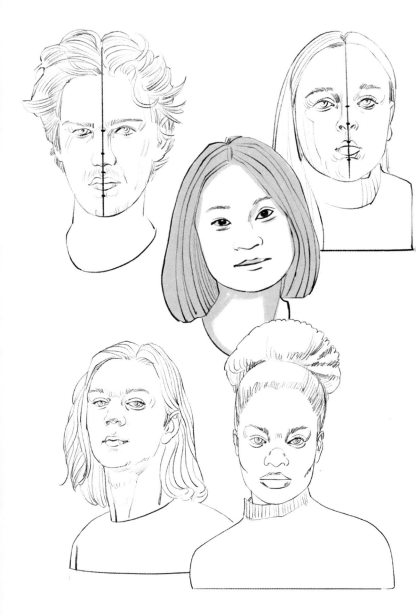

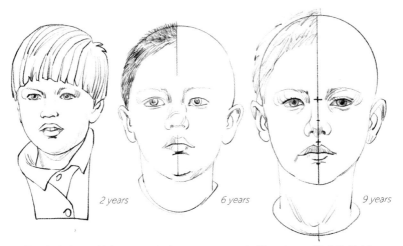

2 years *6 years* *9 years*

This final plate, which represents the same person at different ages (2, 6, 9, 11, 15, and 18 years old), is intended as a summary. We can see here the curves of early childhood, the elongation of the face over the years, and the development of the jaw that comes with maturity.

Above, we saw that the childlike characteristics most often used in animated movies, comics, and graphic novels (particularly in manga) can be verified from photos: a rounder head, relatively larger eyes, a rounded tip of the nose, and a less obvious nasal ridge.

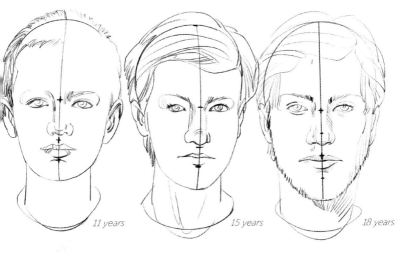

11 years *15 years* *18 years*

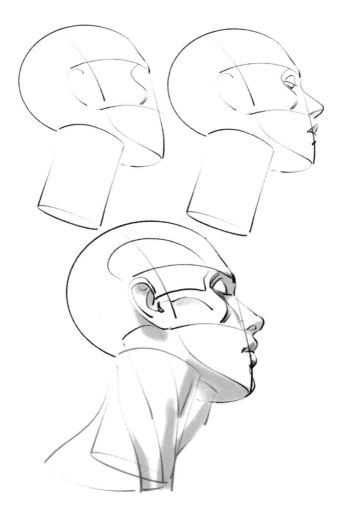

Basic Shapes

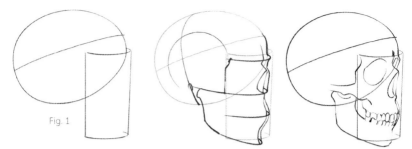

Fig. 1: Here we can see the egg shape (ovoid) of the skull, with its tip on the forehead, and the face in the shape of a roofing tile, so as not to flatten the facial elements.

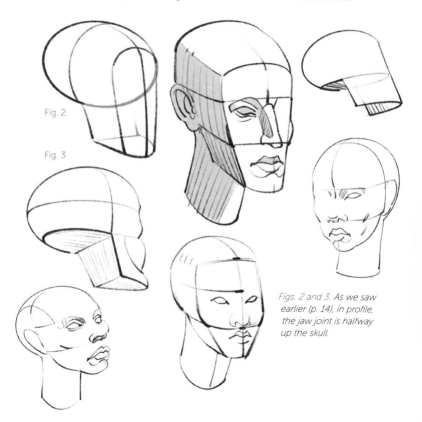

Figs. 2 and 3: As we saw earlier (p. 14), in profile, the jaw joint is halfway up the skull.

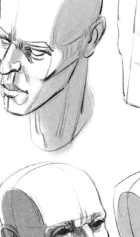

We use the proportions spelled out in the previous chapter to then position the eyes (halfway up) and the ear (at nose height, just behind the jaw joint).

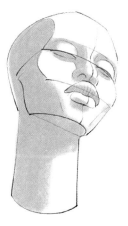

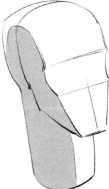

On this two-page spread, the main planes that structure the face are emphasized (shaded areas).

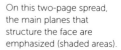

Fig. 1: The brow bone forms a ridge that appears to shelter the eyes. Here the upper lip echoes that structure, but the lower lip can also be the more prominent one.

Fig. 1

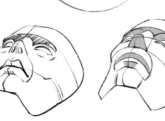

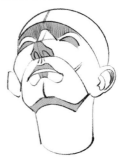

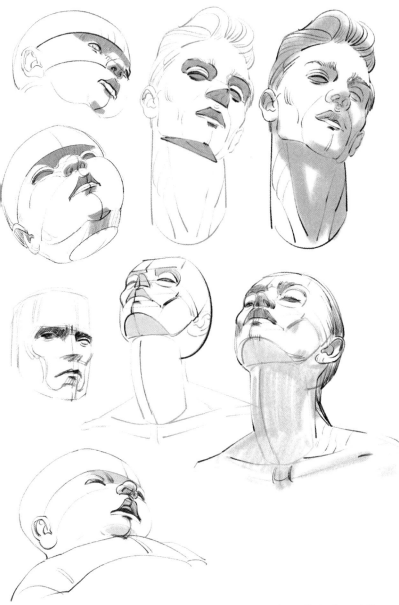

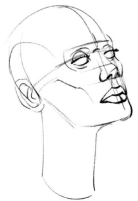
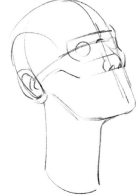
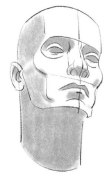

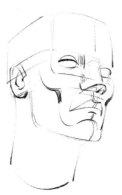
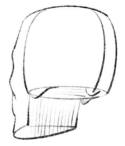
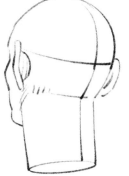

The bony edge of the cheekbone is a valuable reference point for both drawing and sculpture. It will help you to translate the viewing angles, especially 3/4 views.

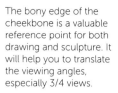
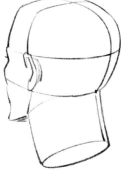
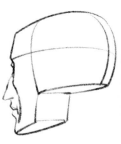

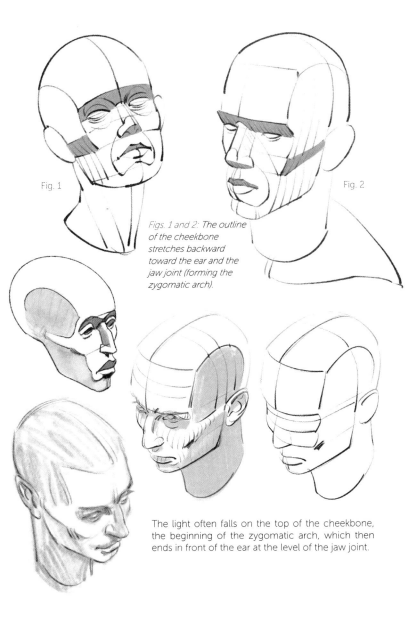

Fig. 1

Fig. 2

Figs. 1 and 2: The outline of the cheekbone stretches backward toward the ear and the jaw joint (forming the zygomatic arch).

The light often falls on the top of the cheekbone, the beginning of the zygomatic arch, which then ends in front of the ear at the level of the jaw joint.

Certain accessories, like the ones chosen on this page, can make the shapes of the body more clearly visible. The elasticity of a cap (Fig. 1) molds itself to and emphasizes the roundness of the head; the geometry of a pair of glasses (Fig. 1) reveals the curved shapes of the face by its contrast; and the ergonomic shape of a pacifier (Fig. 2) molds itself to the arc of the mouth.

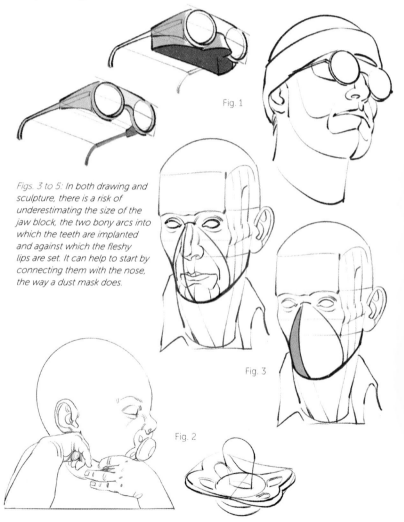

Fig. 1

Figs. 3 to 5: In both drawing and sculpture, there is a risk of underestimating the size of the jaw block, the two bony arcs into which the teeth are implanted and against which the fleshy lips are set. It can help to start by connecting them with the nose, the way a dust mask does.

Fig. 3

Fig. 2

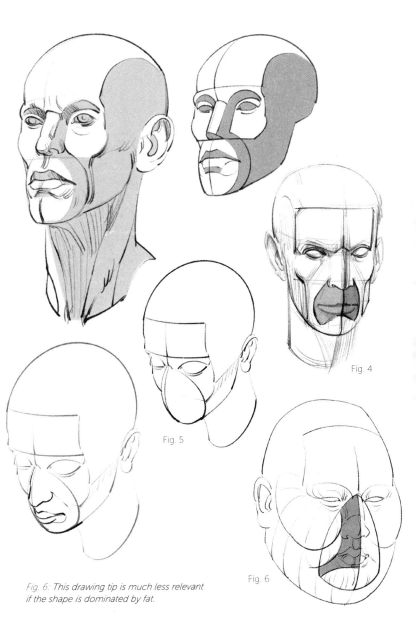

Fig. 4

Fig. 5

Fig. 6

Fig. 6: This drawing tip is much less relevant if the shape is dominated by fat.

The goal of these drawings is to help you create a bust.

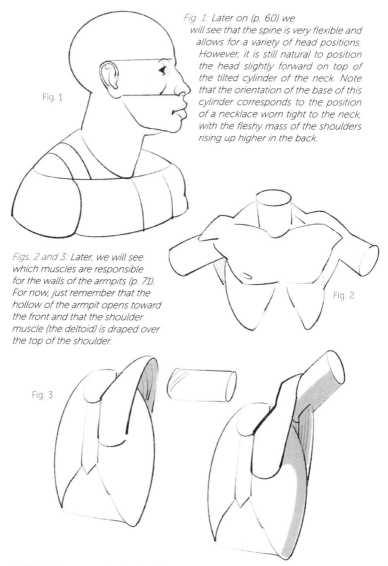

Fig. 1: Later on (p. 60) we will see that the spine is very flexible and allows for a variety of head positions. However, it is still natural to position the head slightly forward on top of the tilted cylinder of the neck. Note that the orientation of the base of this cylinder corresponds to the position of a necklace worn tight to the neck, with the fleshy mass of the shoulders rising up higher in the back.

Fig. 1

Figs. 2 and 3: Later, we will see which muscles are responsible for the walls of the armpits (p. 71). For now, just remember that the hollow of the armpit opens toward the front and that the shoulder muscle (the deltoid) is draped over the top of the shoulder.

Fig. 2

Fig. 3

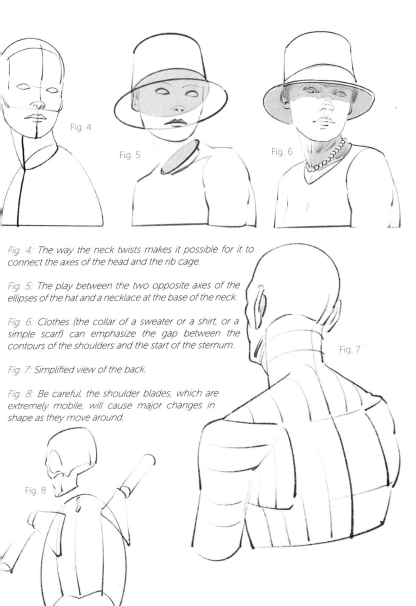

Fig. 4: The way the neck twists makes it possible for it to connect the axes of the head and the rib cage.

Fig. 5: The play between the two opposite axes of the ellipses of the hat and a necklace at the base of the neck.

Fig. 6: Clothes (the collar of a sweater or a shirt, or a simple scarf) can emphasize the gap between the contours of the shoulders and the start of the sternum.

Fig. 7: Simplified view of the back.

Fig. 8: Be careful, the shoulder blades, which are extremely mobile, will cause major changes in shape as they move around.

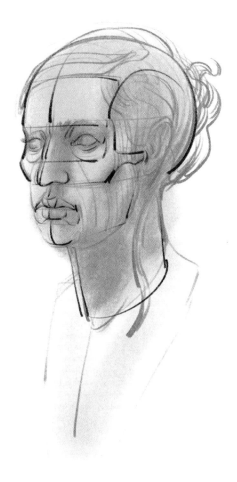

Skeleton and Bone
Reference Points

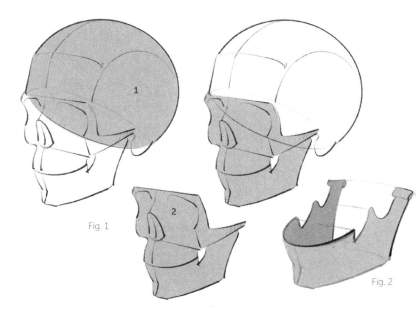

Fig. 1: Cutting the skull into three elements. The cranial box, a true ovoid exoskeleton, envelops and protects the brain (1). The facial bones are wedged underneath the forehead, and the orbital and nasal cavities overhang the two bony arcs that support the teeth (2).

Fig. 2: The lower jaw (mandible), the only mobile bone on the skull, is taken out of this set.

Figs. 3 to 5: When they are put together, the two orbital frames and the zygomatic arches look like an upside-down pair of glasses. The inverted circumflex accent is placed in the upper notch.

Fig. 4: Diagram showing how to use this "pair of glasses."

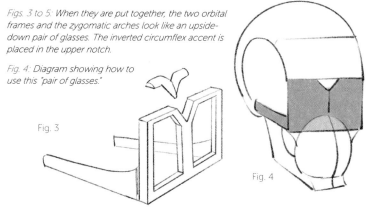

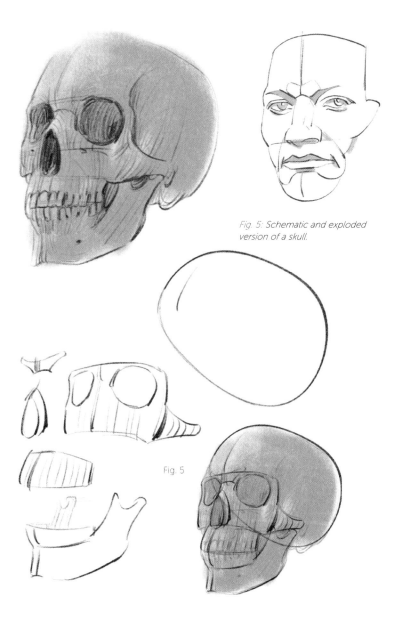

Fig. 5: Schematic and exploded version of a skull.

Fig. 5

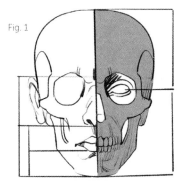

Fig. 1

Fig. 1: The proportions that we looked at in the first chapter will help us to position the various construction points for the skull. Placing the eyes at the halfway point of the height of the skull will allow us to draw the frame of the orbits; the nose will coincide with the naval cavity, and the lips will theoretically meet halfway up in front of the upper incisors.

Fig. 2: On the profile, the lower jaw joint is halfway back, and the ear is positioned on top of the ear hole at the height of the nose.

Note that, in profile, half of the eyeball extends beyond the orbital frame.

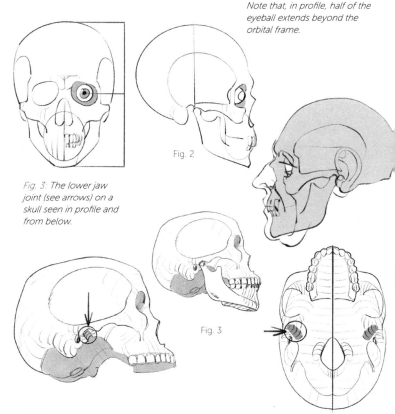

Fig. 2

Fig. 3: The lower jaw joint (see arrows) on a skull seen in profile and from below.

Fig. 3

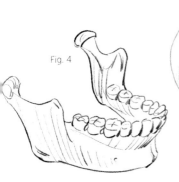

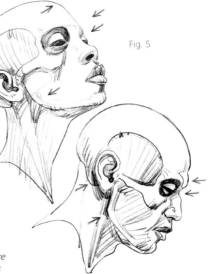

Fig. 4

Fig. 5

Fig. 4: Lower jaw (mandible).

Figs. 5 and 6: Very often, what we call gendered characteristics are not very marked, and there are many shapes that are androgynous; many of the drawings in this book bear witness to this.

Despite what is stated in the caption above, differences in strength and in muscle mass do have repercussions for the skeleton, which has to adapt to them. A female skeleton is lighter and finer, and the muscle insertions are softer. A male skeleton, conversely, is more robust, with more defined muscle insertions. This difference in strength can be found on the skull, especially at the level of the jaw and the chewing muscles (see p. 66). The consequences are a larger mandible, and specifically its squarer angle; eyebrow ridges that contain the pressure (making the forehead more receding, but the root of the nose more clearly marked as a result); and a thicker mastoid eminence (see p. 68).

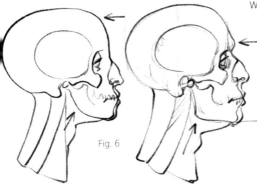

Fig. 6

When it is associated with a thinner musculature, the angle of the jaw is rounder, less protruding, and the eyebrow ridges are nonexistent (a more vertical forehead makes a sharper angle with the top of the skull, with the nose working as an extension of the forehead).

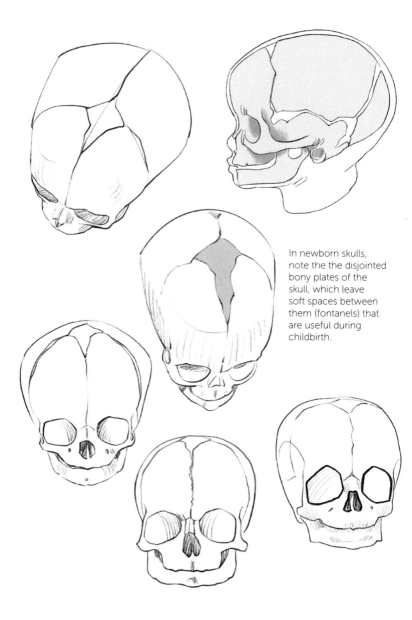

In newborn skulls, note the the disjointed bony plates of the skull, which leave soft spaces between them (fontanels) that are useful during childbirth.

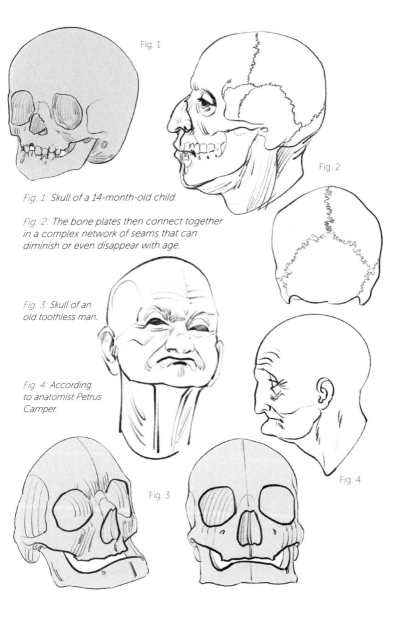

Fig. 1

Fig. 2

Fig. 1: Skull of a 14-month-old child.

Fig. 2: The bone plates then connect together in a complex network of seams that can diminish or even disappear with age.

Fig. 3: Skull of an old toothless man.

Fig. 4: According to anatomist Petrus Camper.

Fig. 3

Fig. 4

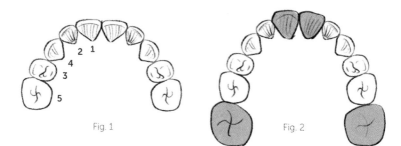

Fig. 1: Order of appearance of the milk teeth (the lower incisors often grow in before the upper incisors).

Fig. 2: Mixed dentition (the permanent teeth are shown as shaded).

Fig. 3: The pressures of the jaws require bony pillars that can thicken (as well as the "brake" provided by the eyebrow ridges) at the expense of the orbital and nasal cavities. (Compare with Fig. 6, p. 49.)

Fig. 4: The teeth form inside the jawbones.

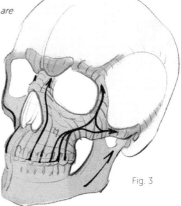

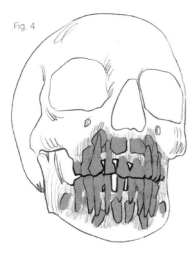

The first teeth usually appear at between 4 and 7 months of age (some children already have one or two teeth at birth). For most children, all of the milk teeth will be in place before the age of 3. The permanent teeth appear starting at age 5 or 6, with the last ones coming in at around 12 years old. The last four molars, also called "wisdom teeth," usually grow in at between 18 and 20 years old (Fig. 6), but they erupt randomly.

Fig. 5

Fig. 6

Fig. 7

Fig. 5: The 28 permanent teeth. The upper incisors partially cover the lower ones, while the molars line up one on top of the other. The upper bony arch is thus a little wider.

Fig. 6: Shaded in, a wisdom tooth. When all four are present, the total number of teeth comes to 32.

Fig. 7: Theoretically, the lips meet halfway up in front of the upper incisors.

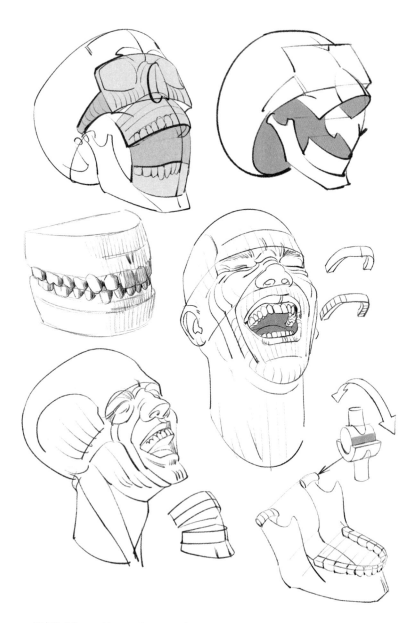

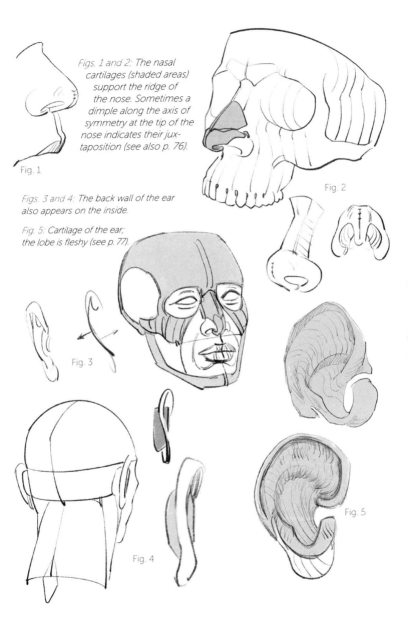

Figs. 1 and 2: The nasal cartilages (shaded areas) support the ridge of the nose. Sometimes a dimple along the axis of symmetry at the tip of the nose indicates their jux- taposition (see also p. 76).

Fig. 1

Figs. 3 and 4: The back wall of the ear also appears on the inside.

Fig. 5: Cartilage of the ear; the lobe is fleshy (see p. 77).

Fig. 2

Fig. 3

Fig. 4

Fig. 5

The skull is obviously the basic element in this morphological analysis. I would say that it is by far the most essential part of our study. Whether in a drawing or a sculpture, this bone will give your portrait the structuring markers that you will rely on for complicated perspectives, particularly in foreshortened views. In the drawings on this double-page spread, I have shaded the bone reference points, in other words, the places where the bone is the dominant determinant of the shape: the forehead, the frame of the eye sockets, the cheekbones, and the edges of the lower jaw. The cartilages of the nose and the ears form hard markers under the skin. The tip of the chin is often thickened by a fleshy shape.

Below, I have left the temples unshaded (to make it easier to see the zygomatic arch), but on the opposite page, I focus on the bone structure.

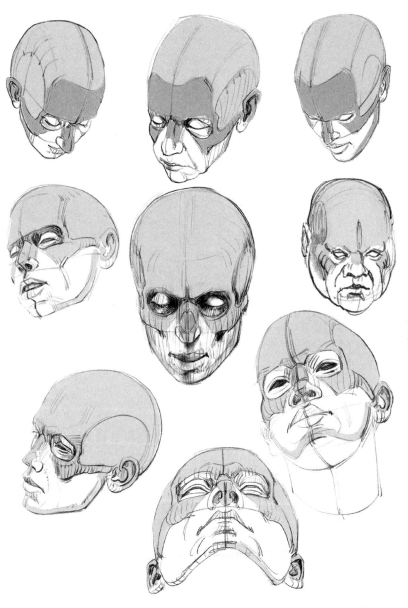

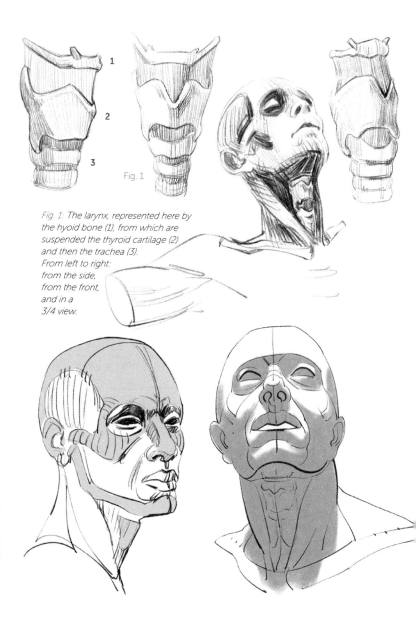

Fig. 1

Fig. 1: The larynx, represented here by the hyoid bone (1), from which are suspended the thyroid cartilage (2) and then the trachea (3).
From left to right:
from the side,
from the front,
and in a
3/4 view.

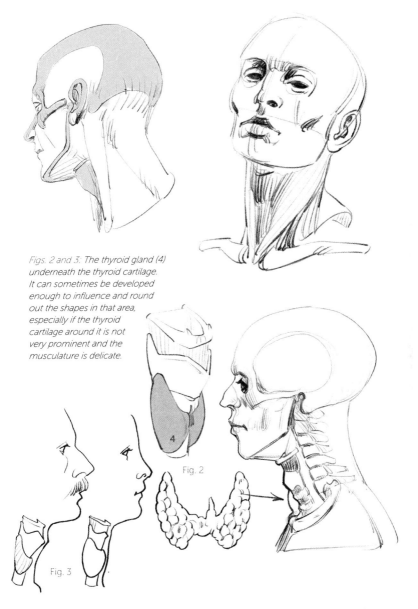

Figs. 2 and 3: The thyroid gland (4) underneath the thyroid cartilage. It can sometimes be developed enough to influence and round out the shapes in that area, especially if the thyroid cartilage around it is not very prominent and the musculature is delicate.

Fig. 2

Fig. 3

Fig. 1: *The seven cervical vertebrae are what give the neck its flexibility. It is only the seventh of them, the lowest down (called "vertebra prominens"), that can be seen underneath the skin.*

The first two vertebrae are remarkable: The first one, the atlas bone, articulates with the skull and allows movements of flexion and extension (when we nod "yes," we are letting our skull slide along this vertebra), while movements of rotation take place on the second vertebra, the axis vertebra (we shake our heads "no" by turning the skull and the atlas bone on this second vertebra).

Fig. 1

Fig. 2: *Rear view of the atlas bone on top of the axis vertebra.*

Fig. 3: *Front view of the atlas bone on top of the axis vertebra (the shaded areas are the surfaces that connect with the skull).*

Fig. 4: *Front views of the axis and atlas vertebrae.*

Fig. 5: *The plane indicating the base of the skull, on top of the atlas and axis bones. To be compared with the drawing on the left.*

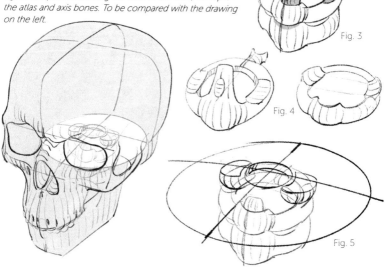

Fig. 2

Fig. 3

Fig. 4

Fig. 5

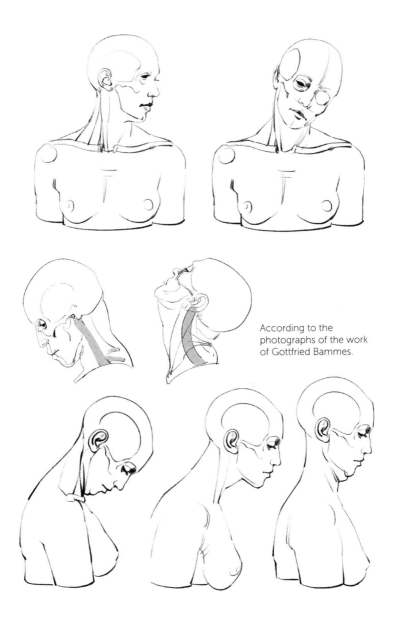

According to the photographs of the work of Gottfried Bammes.

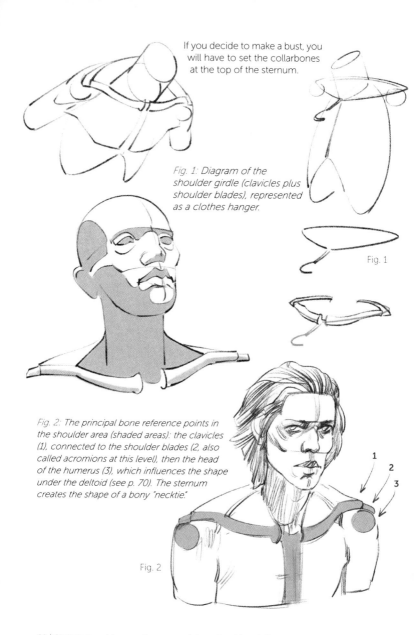

If you decide to make a bust, you will have to set the collarbones at the top of the sternum.

Fig. 1: Diagram of the shoulder girdle (clavicles plus shoulder blades), represented as a clothes hanger.

Fig. 1

Fig. 2: The principal bone reference points in the shoulder area (shaded areas): the clavicles (1), connected to the shoulder blades (2, also called acromions at this level), then the head of the humerus (3), which influences the shape under the deltoid (see p. 70). The sternum creates the shape of a bony "necktie."

1
2
3

Fig. 2

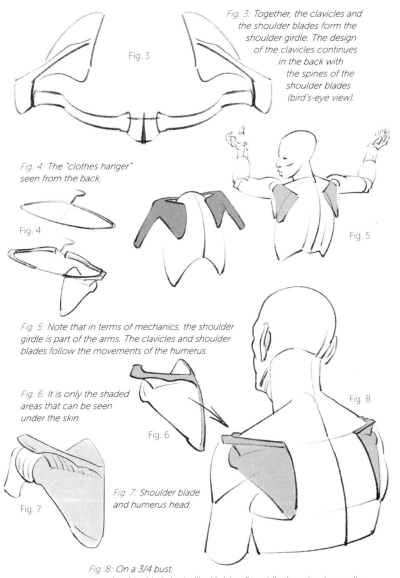

Fig. 3: Together, the clavicles and the shoulder blades form the shoulder girdle. The design of the clavicles continues in the back with the spines of the shoulder blades (bird's-eye view).

Fig. 4: The "clothes hanger" seen from the back.

Fig. 5: Note that in terms of mechanics, the shoulder girdle is part of the arms. The clavicles and shoulder blades follow the movements of the humerus.

Fig. 6: It is only the shaded areas that can be seen under the skin.

Fig. 7: Shoulder blade and humerus head.

Fig. 8: On a 3/4 bust, one shoulder blade looks like it's lying flat while the other is receding.

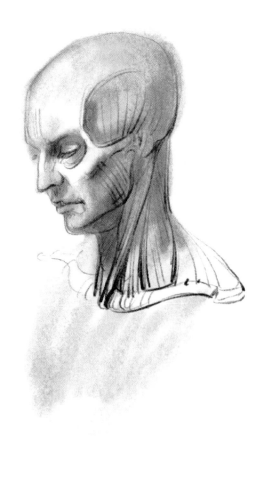

Musculature

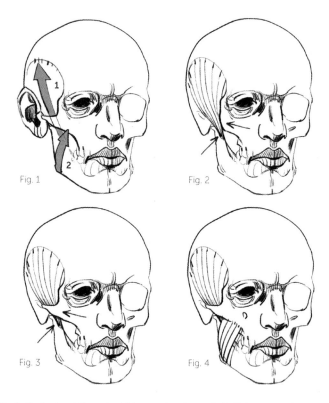

Fig. 1: On the head, the only visible muscles, due to their thickness, are the two masticatory muscles—the temporalis (1) and the masseter (2)—inserted into the only mobile bone in the skull, which is the lower jaw (or mandible).

Fig. 2: The temporalis muscle, with the zygomatic arch sectioned to show the muscle's insertion into the mandible.

Fig. 3: The temporalis muscle, whose end slides under the bony bridge of the zygomatic arch.

Fig. 4: The masseter muscle, whose force is in close correlation with the angle formed by the mandible (see p. 49).

The zygomatic arch thus forms a bridge that allows for the two muscles to be superimposed on top of each other.

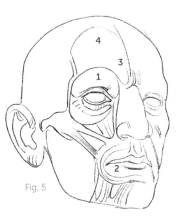

Fig. 5

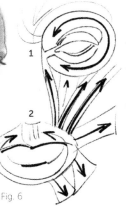

3

1

2

Fig. 6

Figs. 5 and 6: Two circular muscles (1 and 2) allow for the occlusion of the eye and the mouth, while a system that radiates around the mouth makes it possible for it to open. The eyebrow muscle (3) and the forehead muscle (4) complete the muscular system around the eyes.

These facial skin muscles have one end that attaches to the underside of the skin. It is not the actual muscle fibers that we draw, but rather their action on the skin: the folds or wrinkles perpendicular to their direction that they cause (see p. 78).

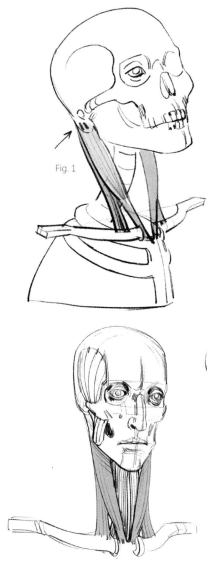

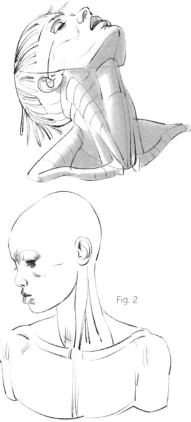

Fig. 1

Fig. 2

Figs. 1 and 2: Behind the ear, there is a bony point on the skull (the mastoid), whose proportions and orientations indicate its connection with the sternocleidomastoid muscle. This muscle lists its attachments in its name: the sternum, clavicle, and mastoid. This muscle is mainly a rotator for the head (Fig. 2).

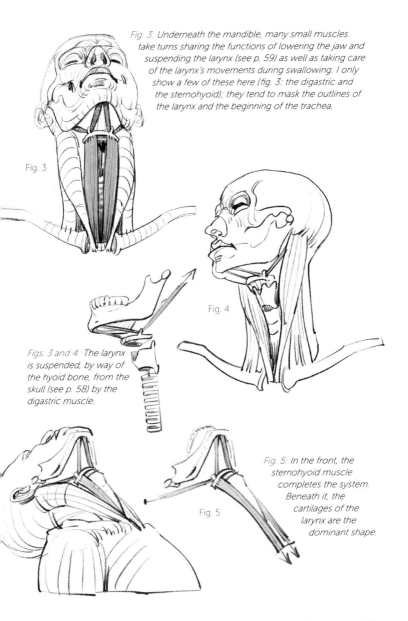

Fig. 3: Underneath the mandible, many small muscles take turns sharing the functions of lowering the jaw and suspending the larynx (see p. 59) as well as taking care of the larynx's movements during swallowing. I only show a few of these here (fig. 3: the digastric and the sternohyoid); they tend to mask the outlines of the larynx and the beginning of the trachea.

Fig. 3

Fig. 4

Figs. 3 and 4: The larynx is suspended, by way of the hyoid bone, from the skull (see p. 58) by the digastric muscle.

Fig. 5

Fig. 5: In the front, the sternohyoid muscle completes the system. Beneath it, the cartilages of the larynx are the dominant shape.

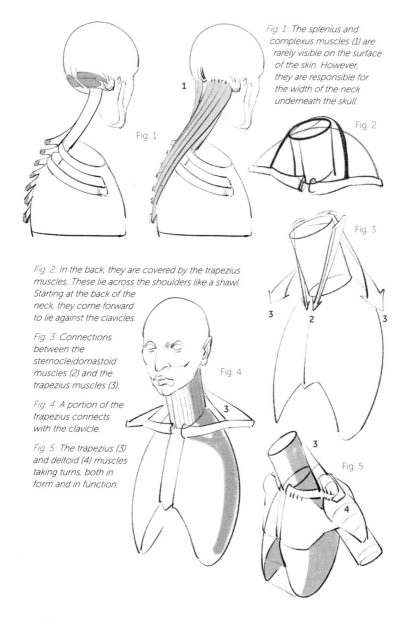

Fig. 1: The splenius and complexus muscles (1) are rarely visible on the surface of the skin. However, they are responsible for the width of the neck underneath the skull.

Fig. 1

1

Fig. 2

Fig. 3

Fig. 2: In the back, they are covered by the trapezius muscles. These lie across the shoulders like a shawl. Starting at the back of the neck, they come forward to lie against the clavicles.

3 2 3

Fig. 3: Connections between the sternocleidomastoid muscles (2) and the trapezius muscles (3).

Fig. 4: A portion of the trapezius connects with the clavicle.

Fig. 4

3

Fig. 5: The trapezius (3) and deltoid (4) muscles taking turns, both in form and in function.

3

Fig. 5

4

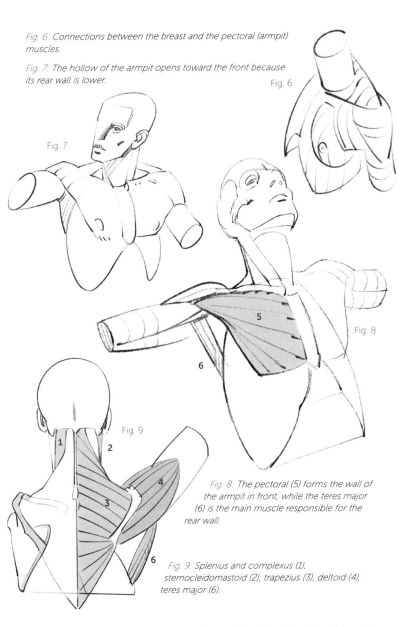

Fig. 6: Connections between the breast and the pectoral (armpit) muscles.

Fig. 7: The hollow of the armpit opens toward the front because its rear wall is lower.

Fig. 6

Fig. 7

Fig. 8

Fig. 9

Fig. 8: The pectoral (5) forms the wall of the armpit in front, while the teres major (6) is the main muscle responsible for the rear wall.

Fig. 9: Splenius and complexus (1), sternocleidomastoid (2), trapezius (3), deltoid (4), teres major (6).

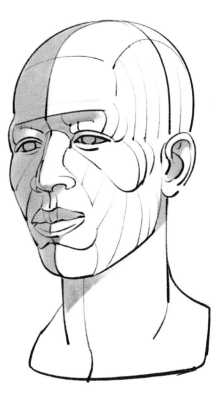

Fat and Skin Folds

Fig. 1

Figs. 1 and 2: Opening and closing of the eyelids. Eyelid fold (1), whose trace persists on the upper eyelid when it is lowered.

Fig. 2

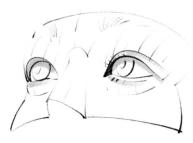

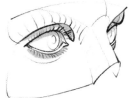

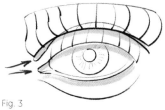

Fig. 3

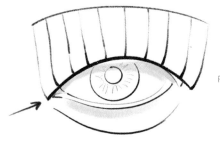

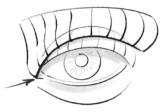

Fig. 3: The eyelid fold can be placed lower down or higher up, and can even cover the upper eyelid.

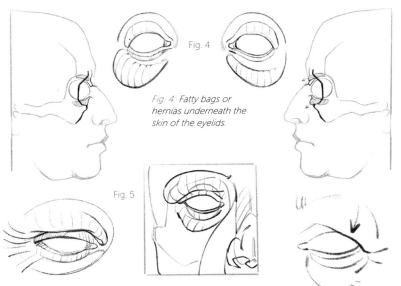

Fig. 4: Fatty bags or hernias underneath the skin of the eyelids.

Fig. 5: The fleshy shape that blends into the upper eyelid sometimes covers the external corner of the orbital frame.

Fig. 6: The swollen eyelids of a newborn.

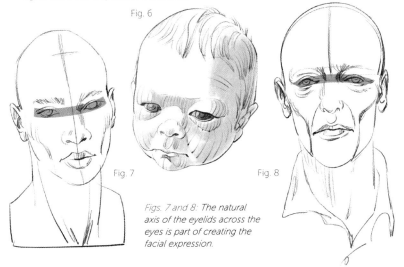

Figs. 7 and 8: The natural axis of the eyelids across the eyes is part of creating the facial expression.

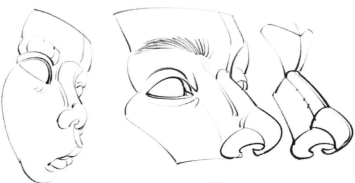

Fig. 1: The upper lip, which looks as if it were suspended from the nasal cartilages. On the sides, two fleshy lines demarcate the dimple under the nose (the philtrum).

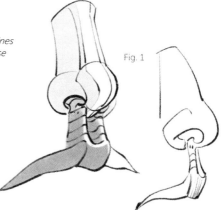

Fig. 1

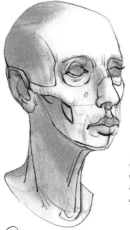

Fig. 2: These profiles look different based on the shape of the nasal cartilages (see p. 55) as well as on how the fleshy ala, or wings, of the nose are attached, which affects the orientation of the nostrils.

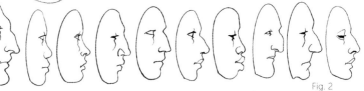

Fig. 2

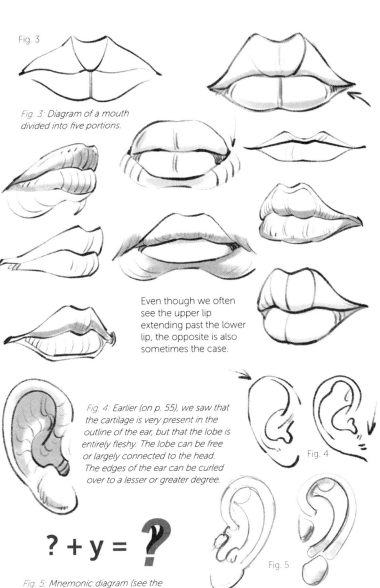

Fig. 3

Fig. 3: Diagram of a mouth divided into five portions.

Even though we often see the upper lip extending past the lower lip, the opposite is also sometimes the case.

Fig. 4: Earlier (on p. 55), we saw that the cartilage is very present in the outline of the ear, but that the lobe is entirely fleshy. The lobe can be free or largely connected to the head. The edges of the ear can be curled over to a lesser or greater degree.

Fig. 4

? + y = ?

Fig. 5: Mnemonic diagram (see the work of Normand Lemay).

Fig. 5

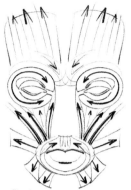

Fig. 1

Wrinkles appear as a result of the repeated action of the facial skin muscles (Fig. 1; see also p. 67). These muscles line the skin, are inserted into it, and extend down to the bone. Their action has the basic mechanical goal of varying the natural openings of the face, around the eyes and mouth, and participating in language and the expression of our emotions. The contractions of these muscles produce the folds and wrinkles of the face, perpendicular to the direction of the muscular fibers. Aside from the masseter and temporalis muscles (see p. 66), which are powerful masticators, it is therefore not the muscles of the face that we draw, but their effect on the skin: namely, the folds and wrinkles

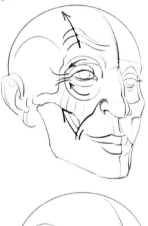

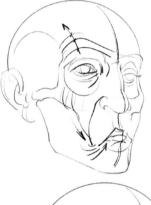

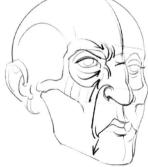

Figs. 2 and 3: For example, one of the muscles that radiates around the mouth attaches to the corner of the lips and then rises to be inserted onto the zygomatic arch. Thus, when it contracts, it makes the edge of the lips move upward, creating a perpendicular fold (and sometimes a dimple), which distorts the cheek and drags down the lower eyelid.

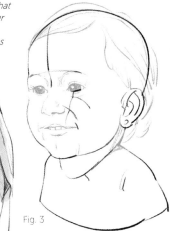

Fig. 2

Fig. 3

Figs. 4 and 5: Here, the lowering of the jaw causes the skin to behave like an elastic band attached to the cheekbones and held down by the chin (see also p. 54).

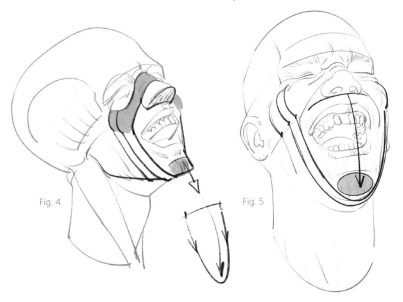

Fig. 4

Fig. 5

The center of this two-page spread shows three people, each at two different ages, with the two ages across from each other.

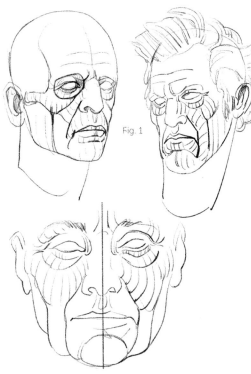

Fig. 1

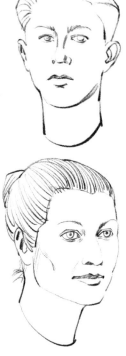

The skin is an elastic envelope, lined with a fatty layer that adheres very closely to its internal surface. The skin obviously plays a very important role, but it never completely masks the principal bone reference points, even in cases of extra weight or obesity. The skull imposes its shape.

Fig. 1: The outcrops of the bone reference points are visible at their peaks. The cranial box, orbital frames, zygomatic arches (or cheekbones), and jaw angles structure the face.

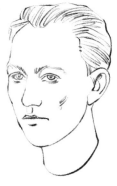

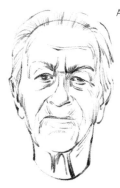

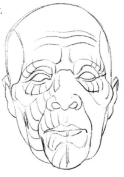

As we age, the skin loses its elasticity, and age draws wrinkles on it. The skin gives the impression of hanging from the skull, which produces outcrops at its peaks, as if we were in a piece of clothing that was too loose. The nose and ears submit to gravity and appear to become longer.

Fig. 2: The contours of the skin no longer coincide with the edges of the jaw, but hang beyond them.

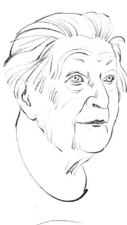

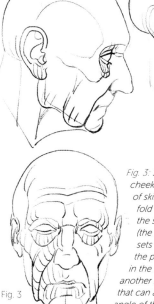

Fig. 2

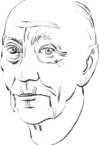

Fig. 3: Starting at the cheekbone, a section of skin defined by the fold that falls from the side of the nose (the nasolabial fold) sets itself off from the point of the chin in the front and from another section of skin that can appear at the angle of the jaw.

Fig. 3

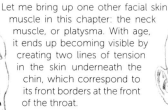

Let me bring up one other facial skin muscle in this chapter: the neck muscle, or platysma. With age, it ends up becoming visible by creating two lines of tension in the skin underneath the chin, which correspond to its front borders at the front of the throat.

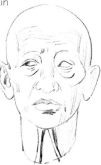

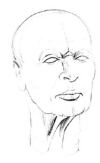

Fig. 1: The platysma muscle lines the skin of the neck. From the chin to the corners of the lips, it then descends beyond the collarbone.

Fig. 1

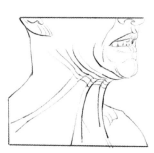

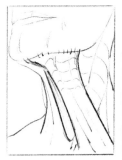

Fig. 2: Contraction of the platysma muscle (it promotes circulation by drawing venous blood and participates in the movements of the lips in this direction).

Fig. 2

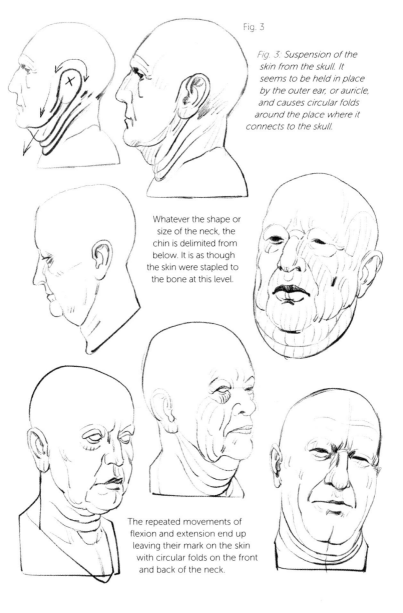

Fig. 3

Fig. 3: Suspension of the skin from the skull. It seems to be held in place by the outer ear, or auricle, and causes circular folds around the place where it connects to the skull.

Whatever the shape or size of the neck, the chin is delimited from below. It is as though the skin were stapled to the bone at this level.

The repeated movements of flexion and extension end up leaving their mark on the skin with circular folds on the front and back of the neck.

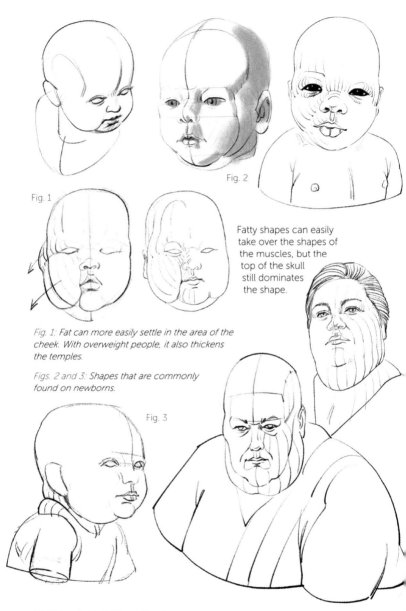

Fig. 1

Fig. 2

Fatty shapes can easily take over the shapes of the muscles, but the top of the skull still dominates the shape.

Fig. 1: Fat can more easily settle in the area of the cheek. With overweight people, it also thickens the temples.

Figs. 2 and 3: Shapes that are commonly found on newborns.

Fig. 3

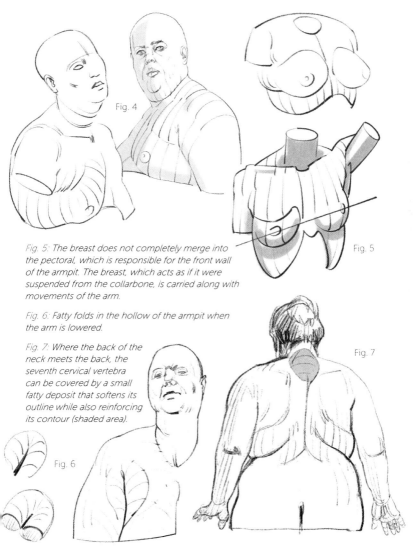

Figs. 4 and 7: On the upper torso, fat creates a shape that connects the breast and/or the pectoral muscle at the front to the tip of the shoulder blade at the back.

Fig. 4

Fig. 5: The breast does not completely merge into the pectoral, which is responsible for the front wall of the armpit. The breast, which acts as if it were suspended from the collarbone, is carried along with movements of the arm.

Fig. 5

Fig. 6: Fatty folds in the hollow of the armpit when the arm is lowered.

Fig. 7: Where the back of the neck meets the back, the seventh cervical vertebra can be covered by a small fatty deposit that softens its outline while also reinforcing its contour (shaded area).

Fig. 7

Fig. 6

Hair, Beard, and Body Hair

The eyebrows protect the eyes and deflect the drops of sweat and rain, and the dust that can get mixed in with them, toward the sides of the face.

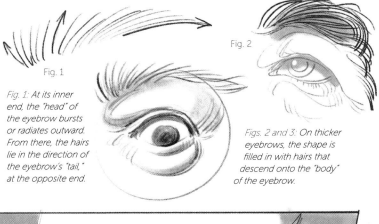

Fig. 1

Fig. 2

Fig. 1: At its inner end, the "head" of the eyebrow bursts or radiates outward. From there, the hairs lie in the direction of the eyebrow's "tail," at the opposite end.

Figs. 2 and 3: On thicker eyebrows, the shape is filled in with hairs that descend onto the "body" of the eyebrow.

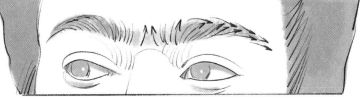

Fig. 3: The eyebrows can converge along the axis of the face at the root of the nose.

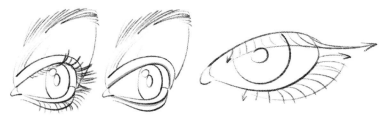

The eyelashes cast a protective shadow over the eyes and function like a sensitive filter. They allow the reflexive movements of the eyelids, which close if an airborne particle, an insect, or anything else threatens our eyes.

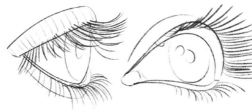

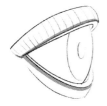

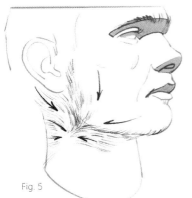

Fig. 4: Lanugo is the name of this fine down that covers the fetus's entire body and can persist until birth (drawn according to a photo).

Fig. 5

Fig. 5: On many models, we can see how the beard hairs converge underneath the angle of the jaw.

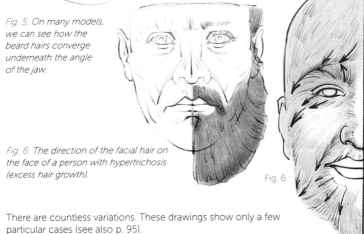

Fig. 6: The direction of the facial hair on the face of a person with hypertrichosis (excess hair growth).

Fig. 6

There are countless variations. These drawings show only a few particular cases (see also p. 95).

In the remainder of this chapter, I will use light value (the degree of light and shadow) more systematically in order to make my point more clearly. The "morpho" approach is not to get carried away with details by drawing the texture before the structure—in other words, the individual hairs before the head of hair. The tips that I offer here are of great use to me personally in drawing trees and other plants that form clusters that appear indistinct at first glance. In each case (a head of hair, a tree), it is a matter of keeping in mind the overall roundness (all of the hairs are positioned on a skull), and then discerning subsets within this overall silhouette (subsets like tufts and strands in the case of hair, or bunches of leaves for each branch in the case of a tree).

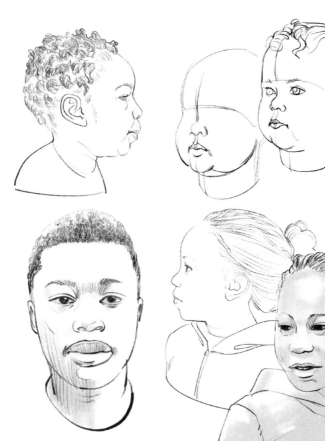

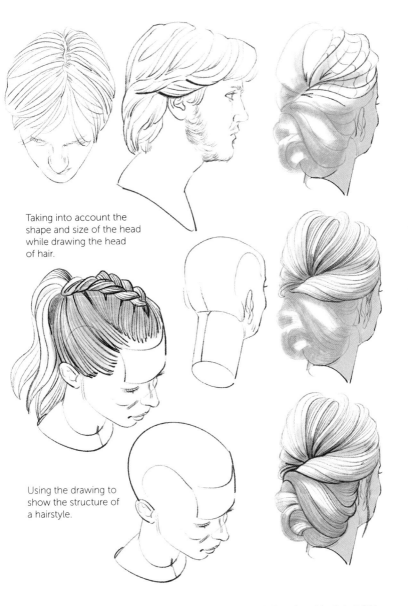

Taking into account the shape and size of the head while drawing the head of hair.

Using the drawing to show the structure of a hairstyle.

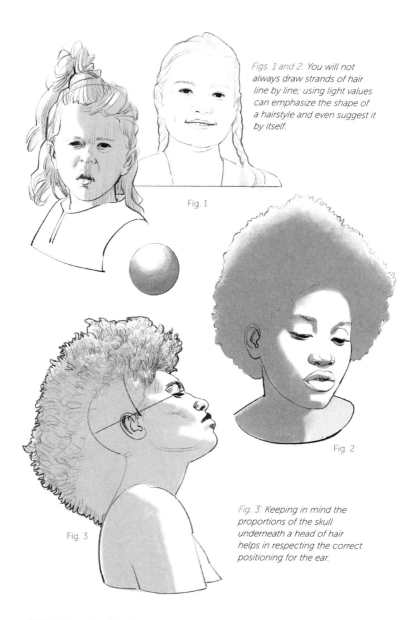

Figs. 1 and 2: You will not always draw strands of hair line by line; using light values can emphasize the shape of a hairstyle and even suggest it by itself.

Fig. 1

Fig. 2

Fig. 3: Keeping in mind the proportions of the skull underneath a head of hair helps in respecting the correct positioning for the ear.

Fig. 3

Some hairstyles and some hair textures are almost fractal in their structure. This means that we find the same pattern at different scales, assuming the same lighting.

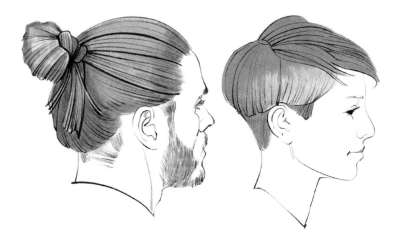

Figs. 1 and 2: Natural "vortex" implantation of the hair at the back of the head.

Fig. 3: Hair loss often occurs in patterns known to cosmetic surgery. Hair loss starting at the center of the hair whorl at the back of the head is a classic form of baldness.

Figures 4 and 5, shown at right, cannot be taken as canonical; there are an infinite number of possible patterns (see the Resources page). They do, however, illustrate the idea, which I continue to find productive and stimulating, that "everything has a shape" and that it can be relevant to observe and/or imagine hair, and the individual hairs, the way that Da Vinci studied fluids by drawing river eddies and whirlpools.

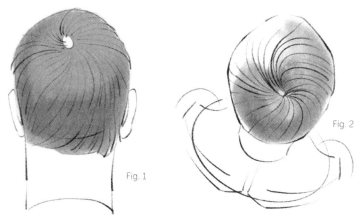

Fig. 1

Fig. 2

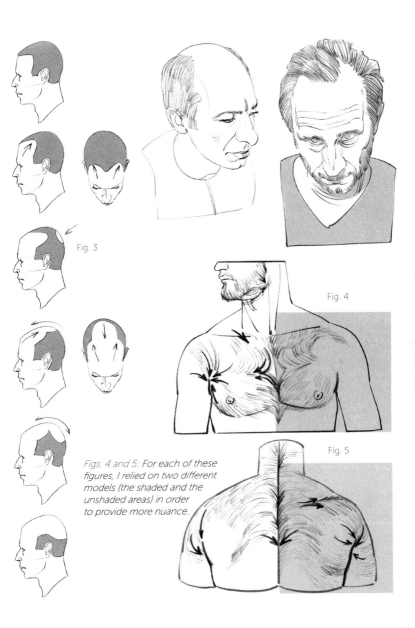

Fig. 3

Fig. 4

Fig. 5

Figs. 4 and 5: For each of these figures, I relied on two different models (the shaded and the unshaded areas) in order to provide more nuance.

RESOURCES

On the subject of hirsuteness, Paul Richer, in *Nouvelle anatomie artistique* (*New artistic anatomy*), *volume 1*, cites the works of Henri Beaunis and Abel Bouchard. However, looking at the many photographs that can be found online of models who are either extremely hairy or suffer from hypertrichosis, I have not seen any true correspondence with the "maps" that these authors provide. Their works can be found on Gallica, the website of the Bibliothèque nationale (the French National Library): https://gallica.bnf.fr.

Fig. 1

Fig. 1:
The temporal vein.

Bammes, Gottfried. *Der nackte Mensch. Hand- und Lehrbuch der Anatomie für Künstler.* Dresden: Verlag der Kunst, 1982.

Goddé-Jolly, Denise, and Jean-Louis Dufier. *Ophtalmologie pédiatrique.* Masson, 1992.

Loomis, Andrew. *Drawing the Head and Hands.* New York: Viking Press, 1956.

Nouveaux éléments d'anatomie descriptive et d'embryologie Paris: J.B. Baillière & fils, 1868.

Richer, Paul. *Canon des proportions du corps humain.* Paris: C. Delagrave, 1893.

Richer, Paul. *Nouvelle anatomie artistique du corps humain,* volume 1. 1906; republished 2013 by the Bibliothèque nationale française.

Richer, Paul. *Nouvelle anatomie artistique du corps humain,* volume 2. Plon, 1920.

ACKNOWLEDGMENTS

I want to thank Viviane Alloing, Gwenaëlle Le Cunff, Carole Rousseau, and Hélène Raviart. My warm thanks to Éric Sulpice, editorial director during the publication of the first ten volumes of this collection, for having believed in this work from the very beginning (soon to be ten years ago now!), and also for having accepted *The Écorché: An Artistic Genre* for publication, a book that is dear to my heart. I wish to thank Eva Tejedor, marketing manager, who spared no efforts to ensure that these books would find their audience. And I most particularly want to thank my editor, Nathalie Tournillon, whose influence has made the form and content of these books the best they could be.